THE LIFE OF THE WORLD'S CUTEST DOG

by

J. H. Lee

Photography by

Gretchen LeMaistre

CHRONICLE BOOKS

SAN FRANCISCO

Library of Congress Cataloging-in-Publication Data available.

ISBN: 978-1-4521-0306-8

Manufactured in China
Designed by Suzanne LaGasa
Photographed by Gretchen LeMaistre

10 9 8

Chronicle Books
680 Second Street
San Francisco, California 94107
www.chroniclebooks.com

MIX
Paper from
responsible sources
FSC® C104723

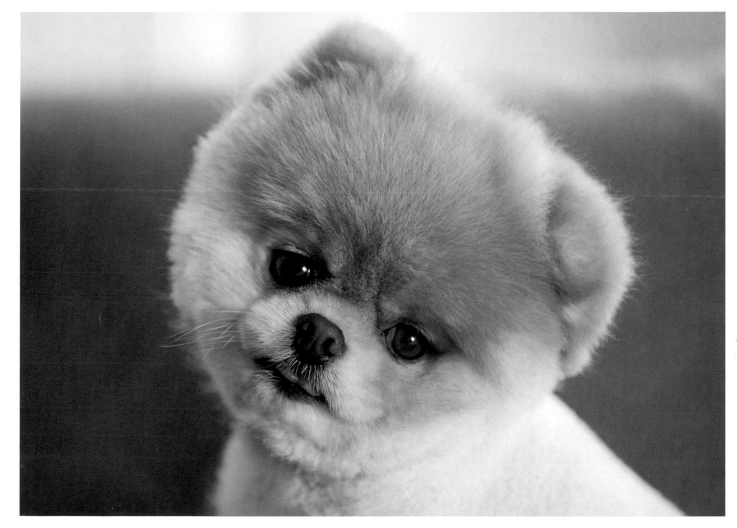

Hello, my name is Boo. This is my life.

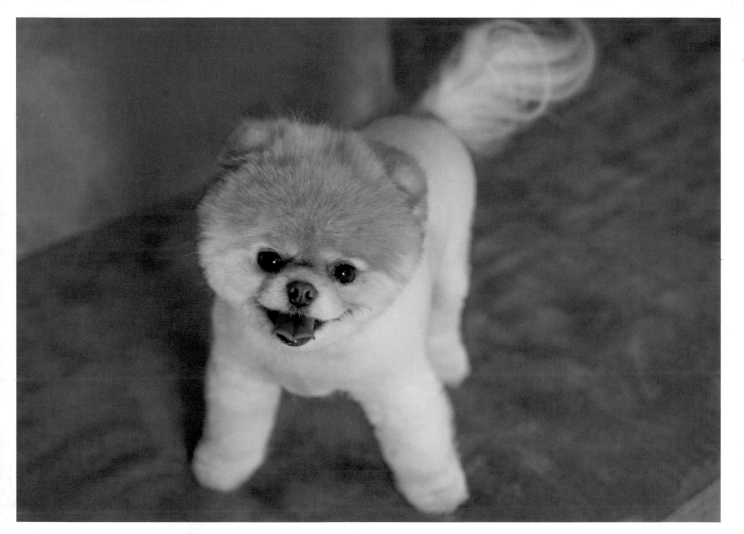

I like to lounge around the house.

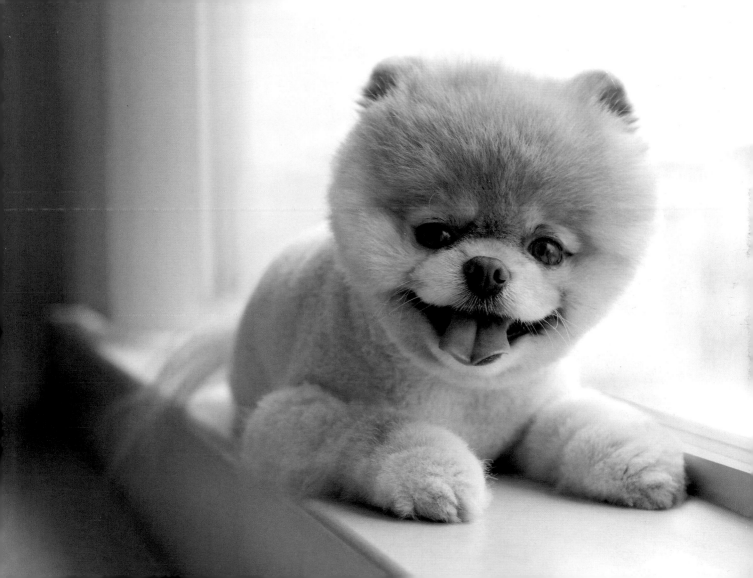

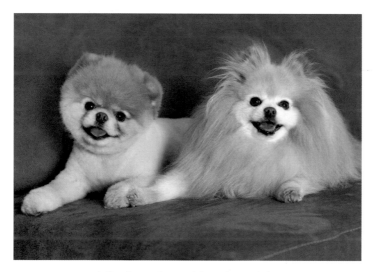

I find my best friend Buddy.

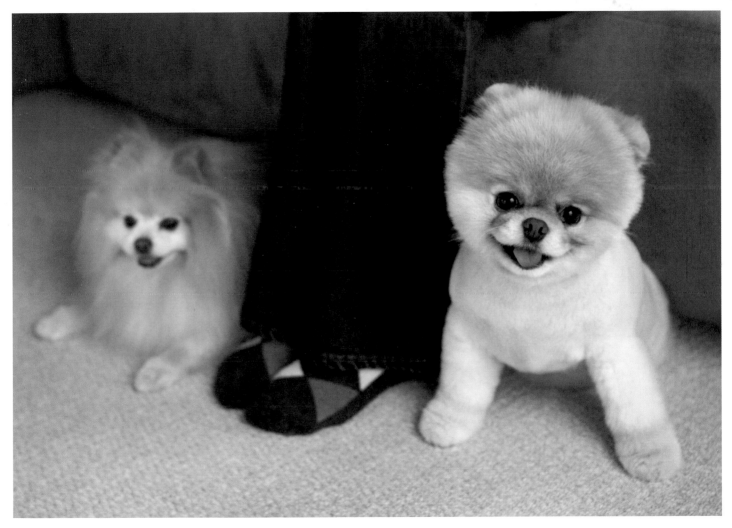

We have family time to discuss our plans.

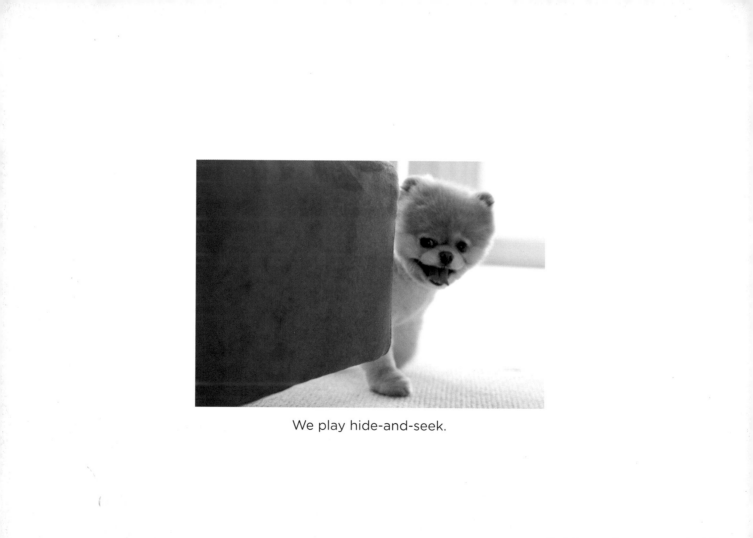

We play hide-and-seek.

But I'm not very good at it.

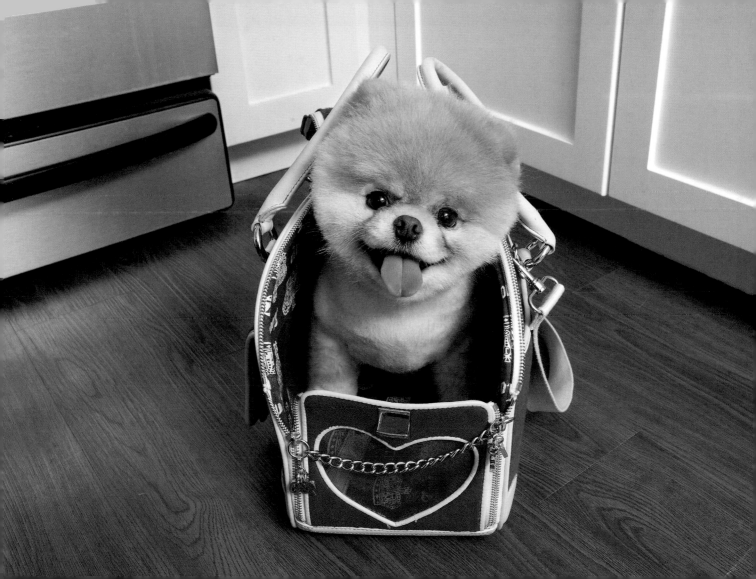

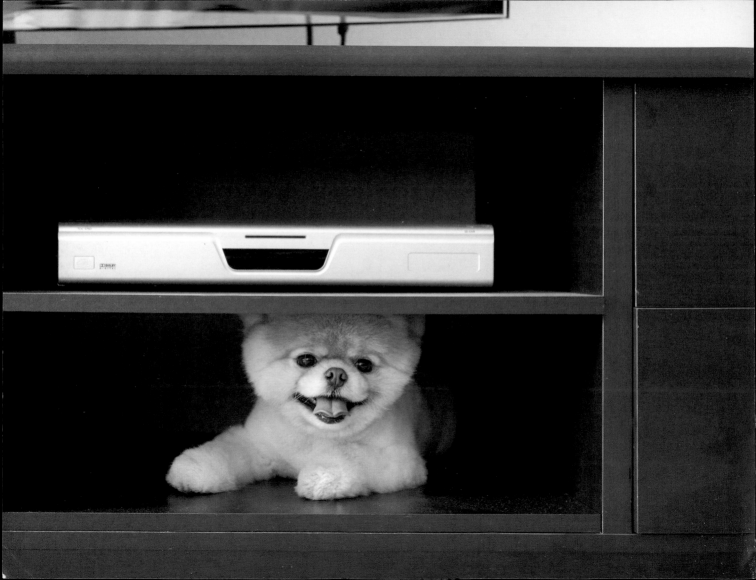

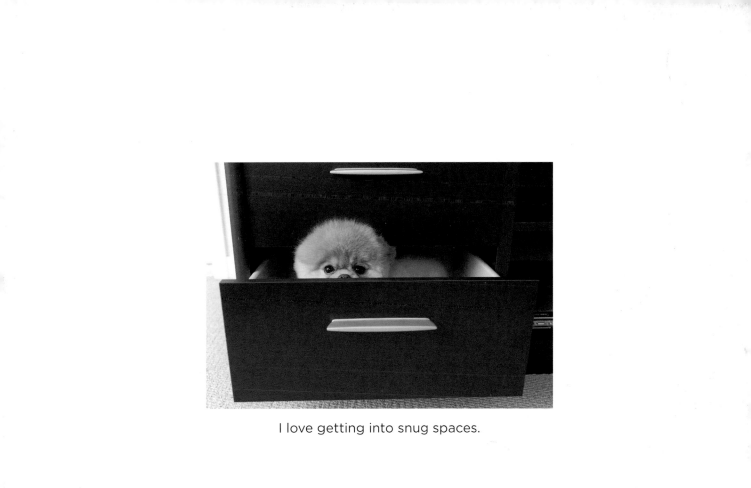

I love getting into snug spaces.

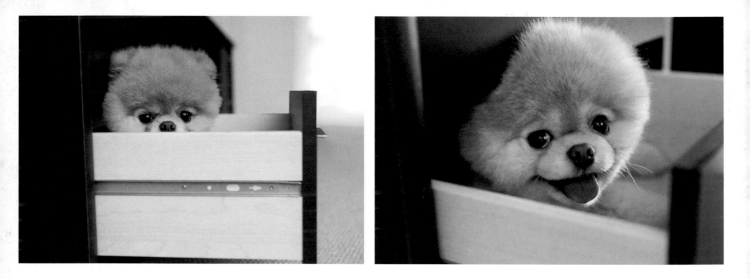

Peekaboo!

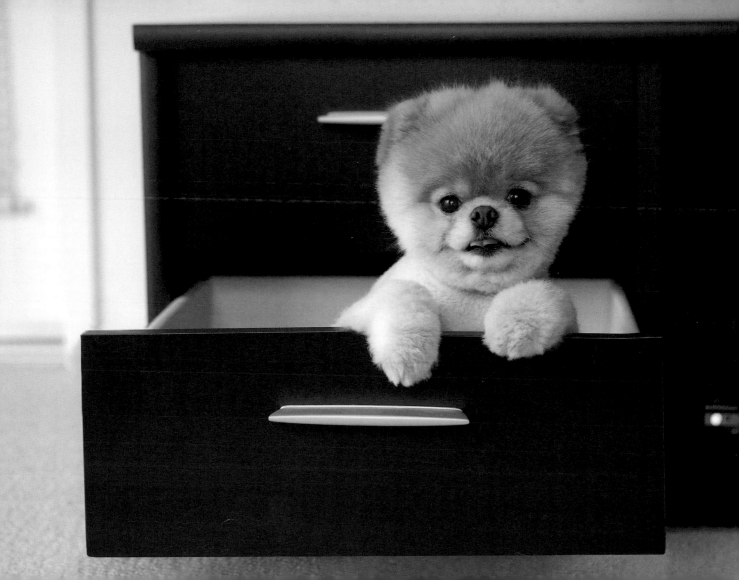

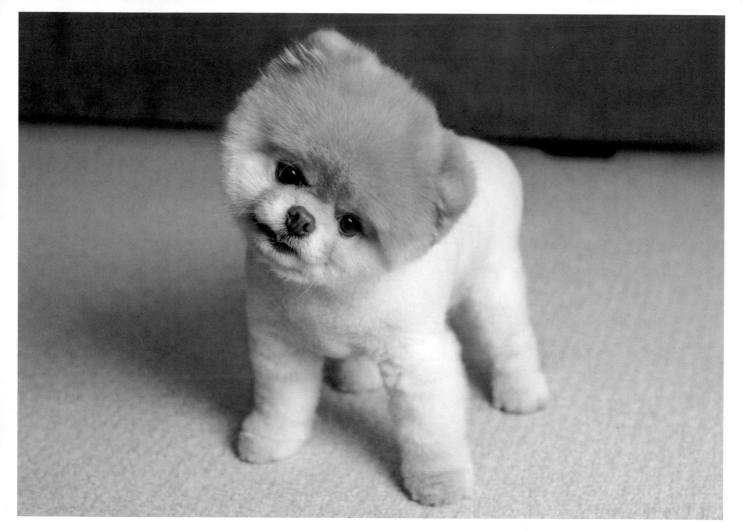

Every day, I make important wardrobe decisions.

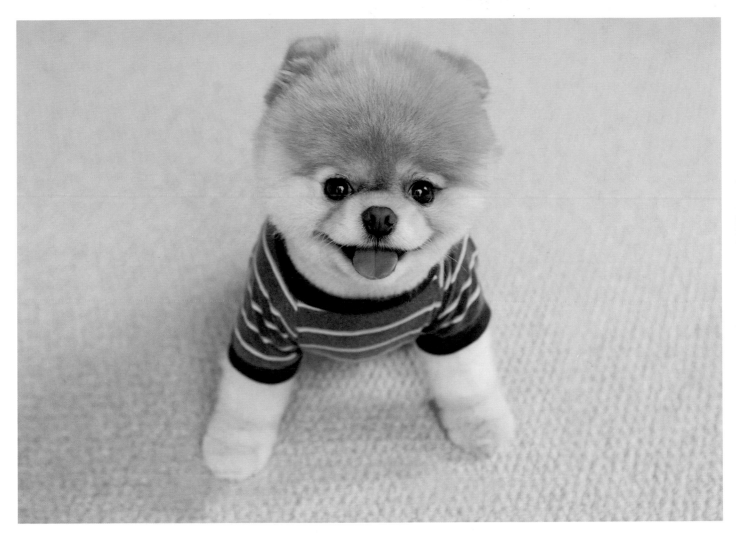

Casual pup

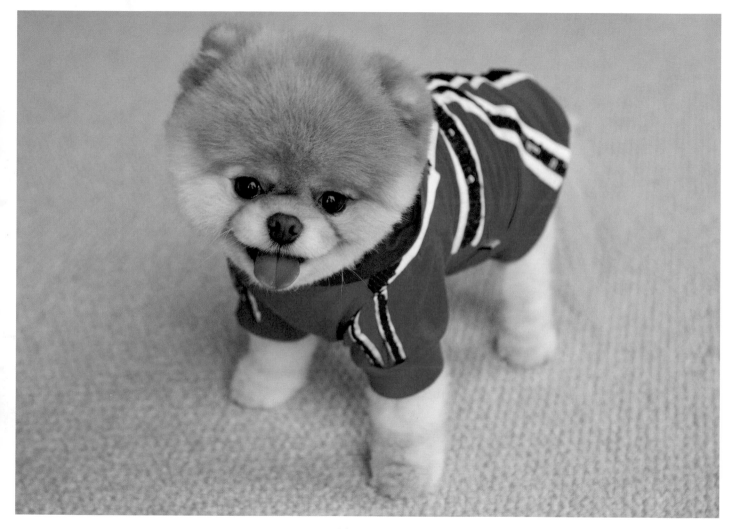

Glam pup

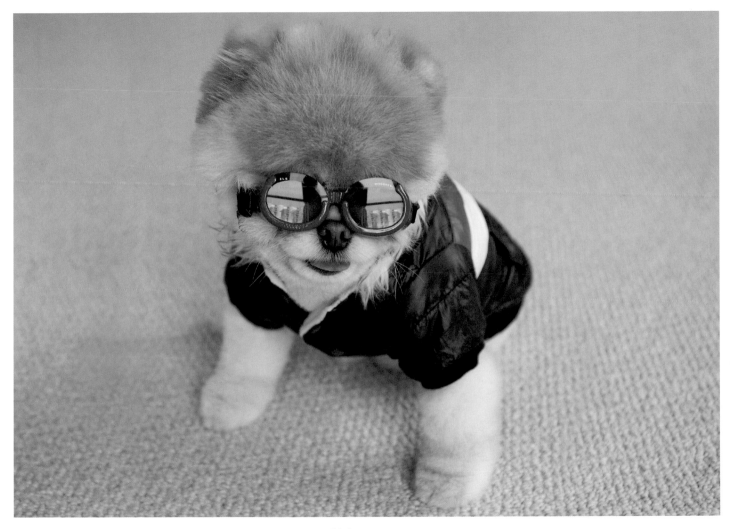

Urban pup

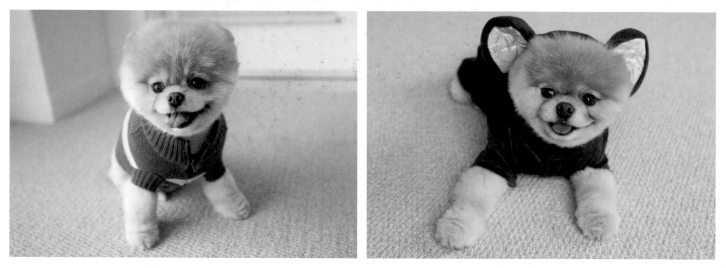

Preppy pup Monkey pup

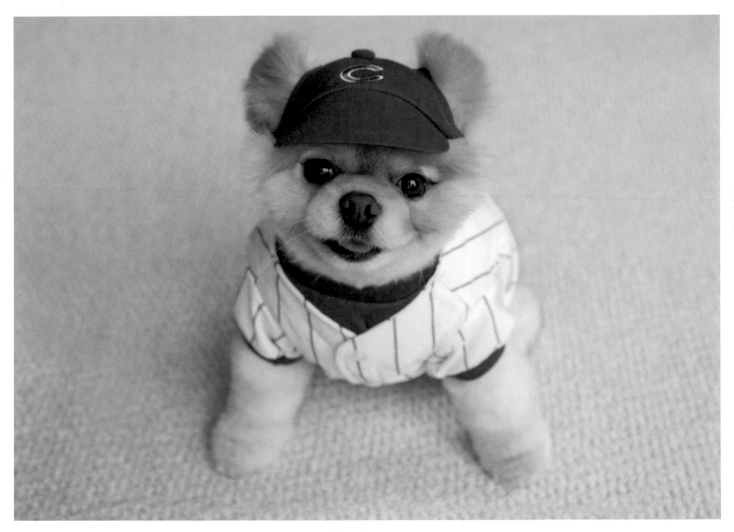

Sporty pup

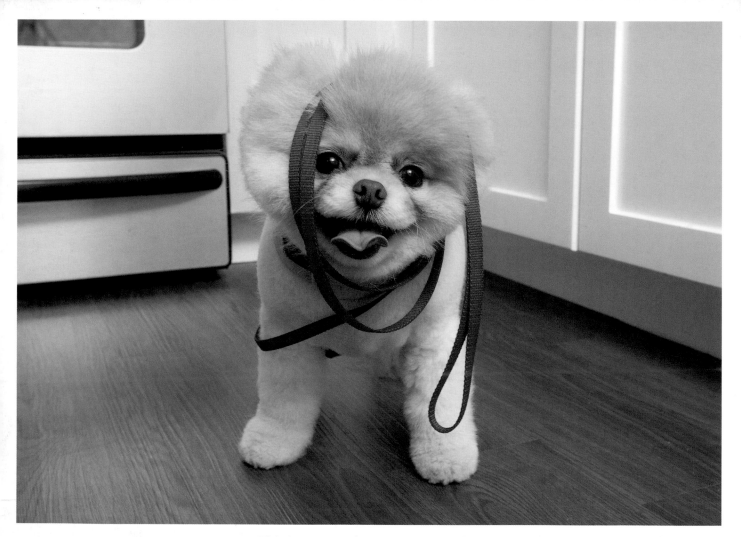

This is my outdoor walking outfit.

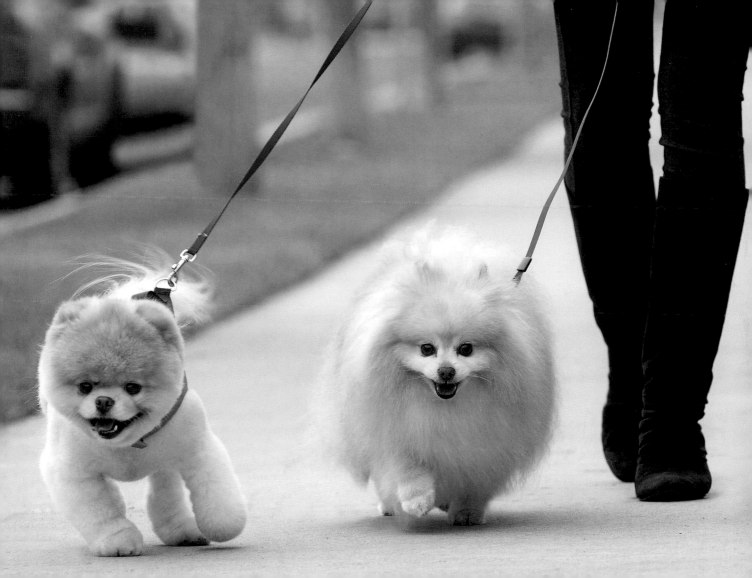

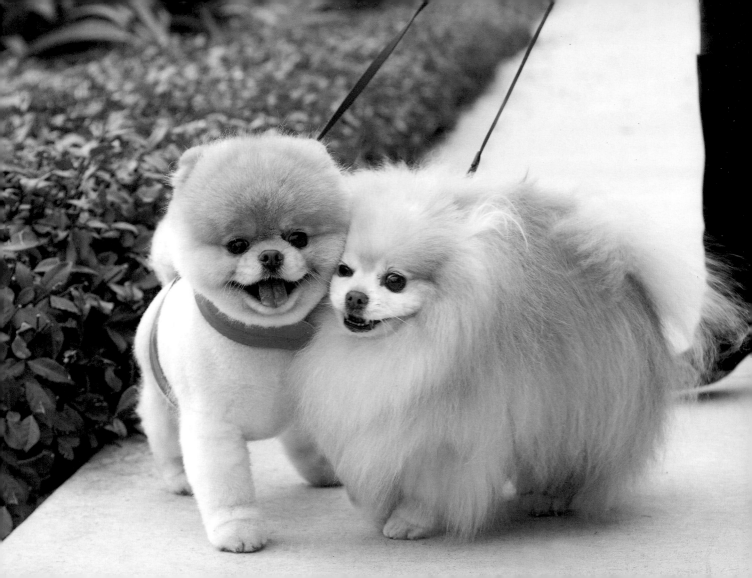

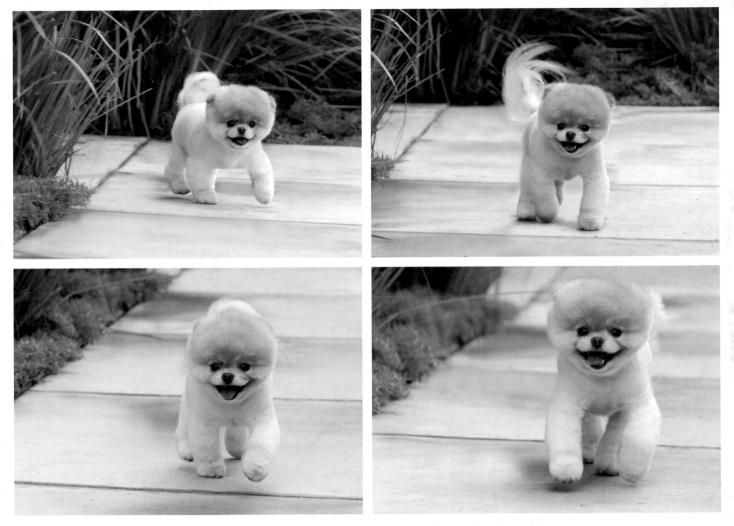

Sometimes I escape the walking outfit, and I take off!

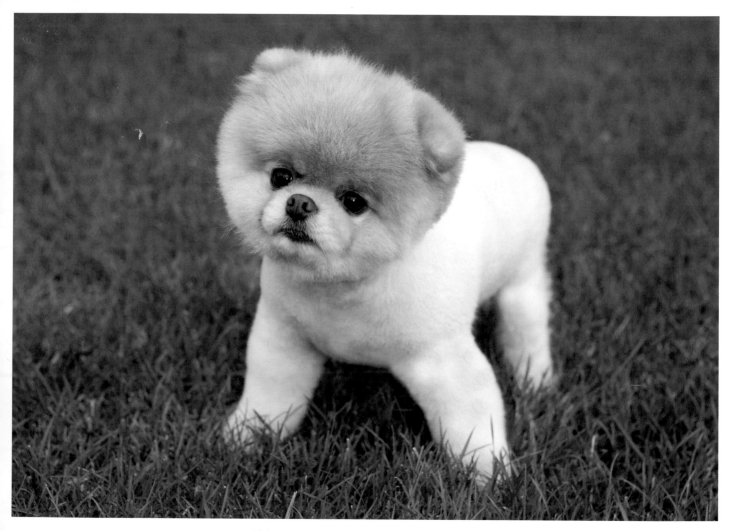

This is my naked-in-the-grass look.

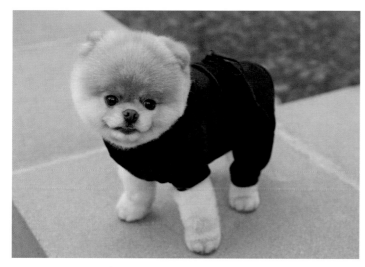

I also sport my running suit.

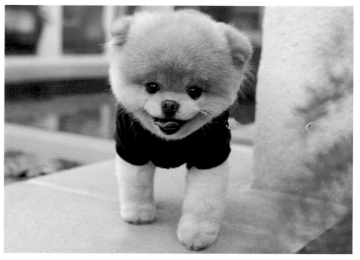

Even when I don't plan on running.

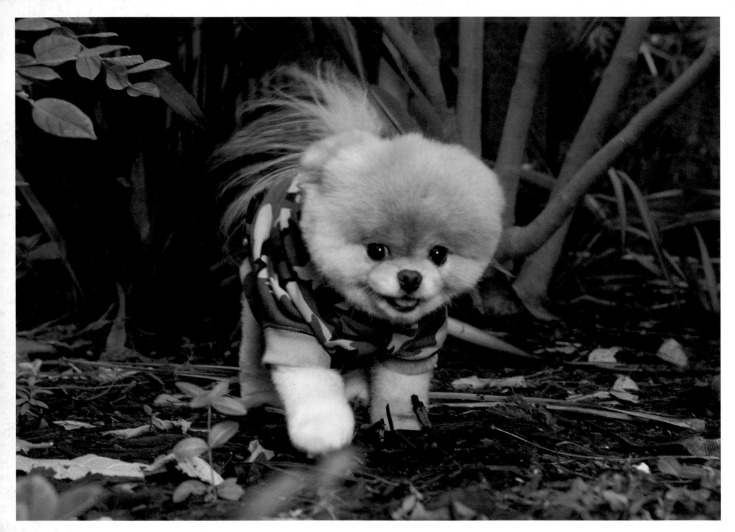

Camouflage comes in handy when I'm out in the wild.

Dog waste is not a fertilizer

**PLEASE KEEP DOGS
OFF THE LAWN**

Thank You

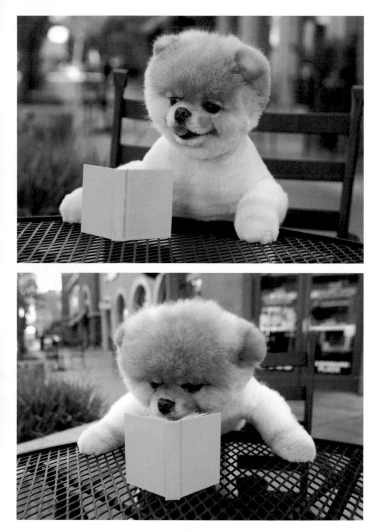

I wind down with a little mental exercise.

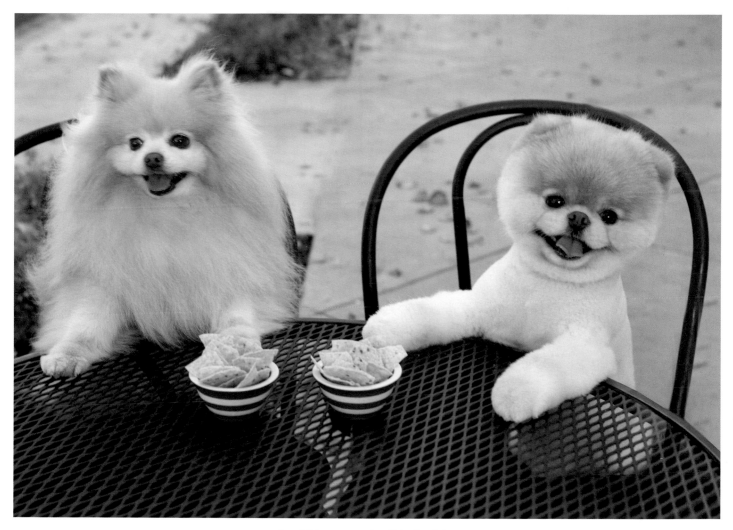

And I hang out with Buddy.

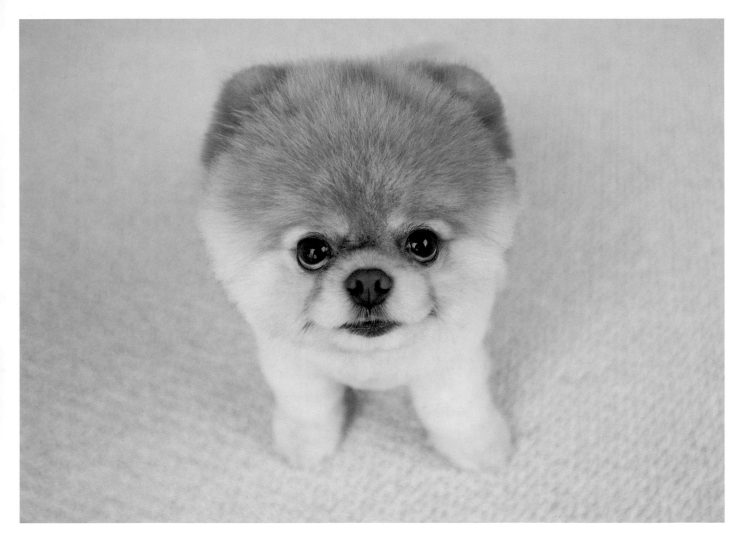

When it's time to eat, I know to say please.

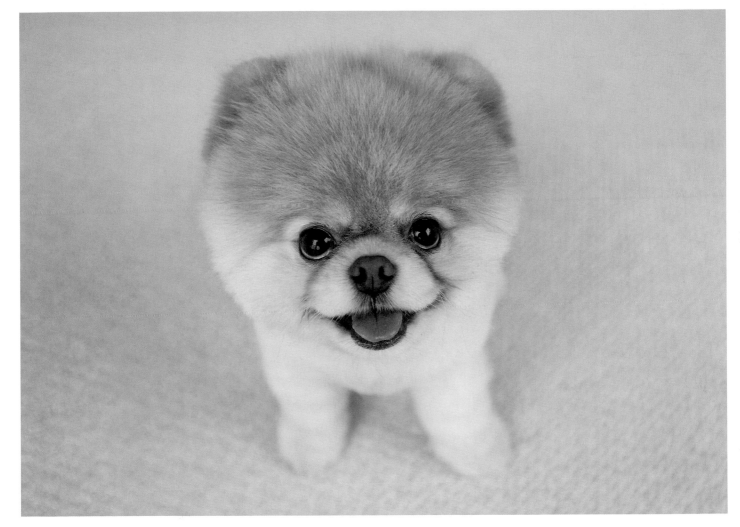

And thank you.

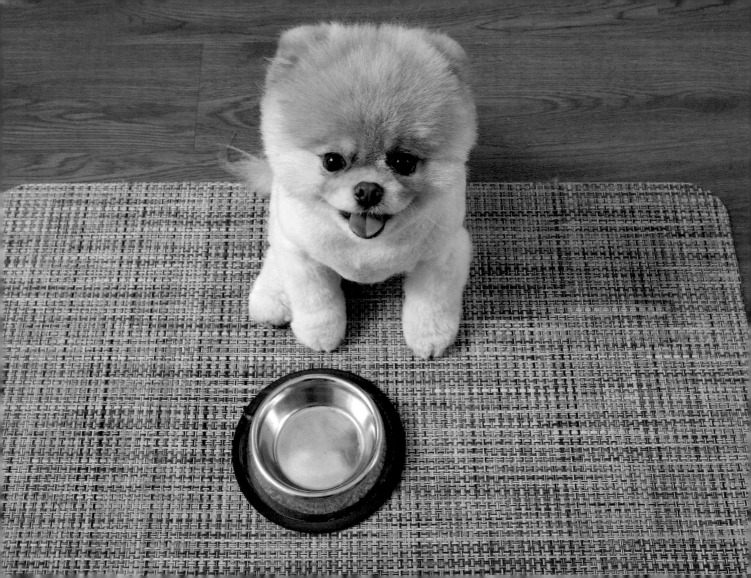

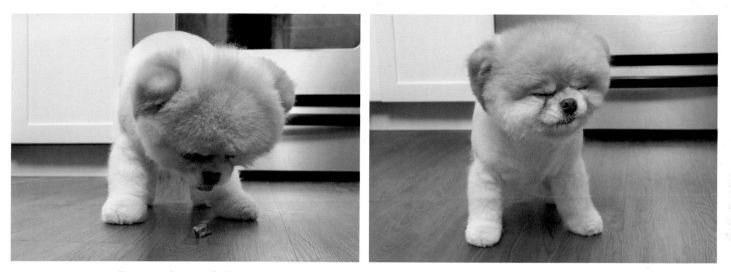

Treats always follow.

Yum!

Nothing says "I'm hungry" like smiling by an empty bowl.

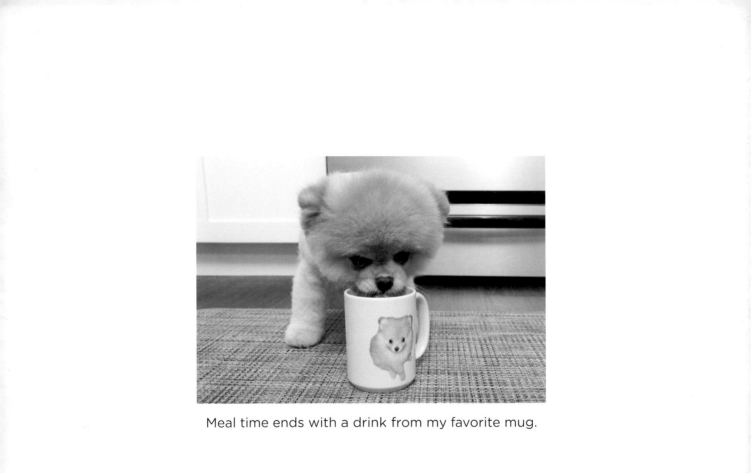

Meal time ends with a drink from my favorite mug.

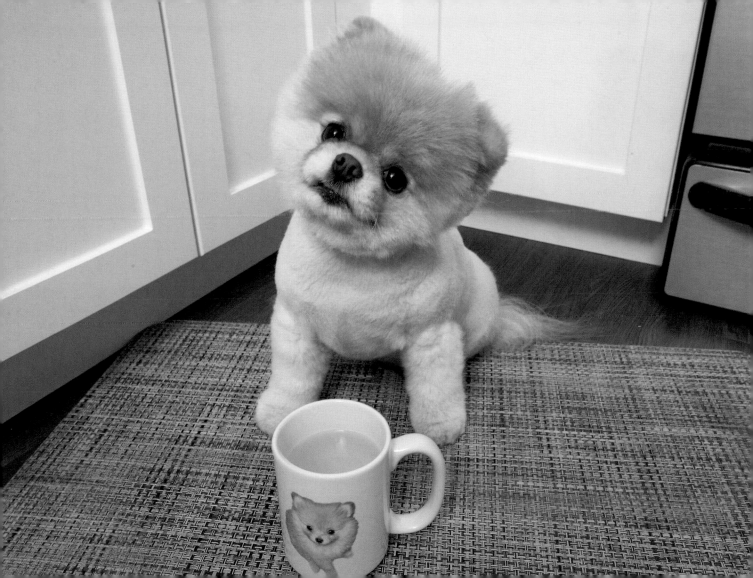

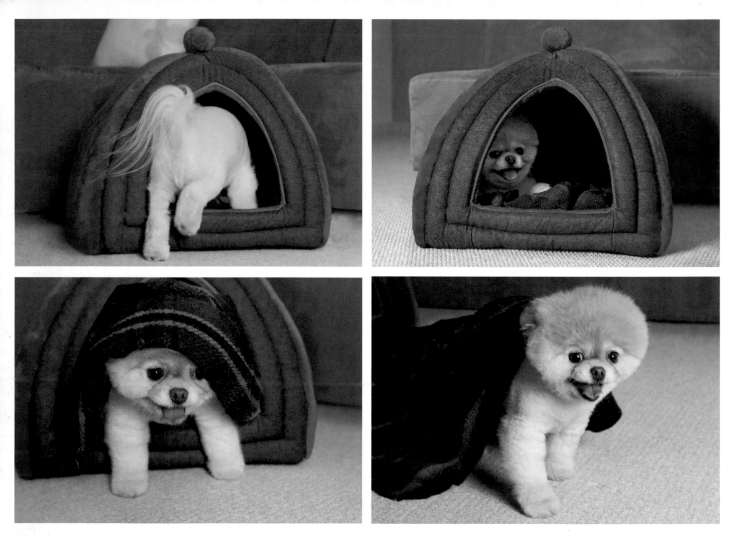

Eating is obviously followed by sleeping. This is where I hibernate.

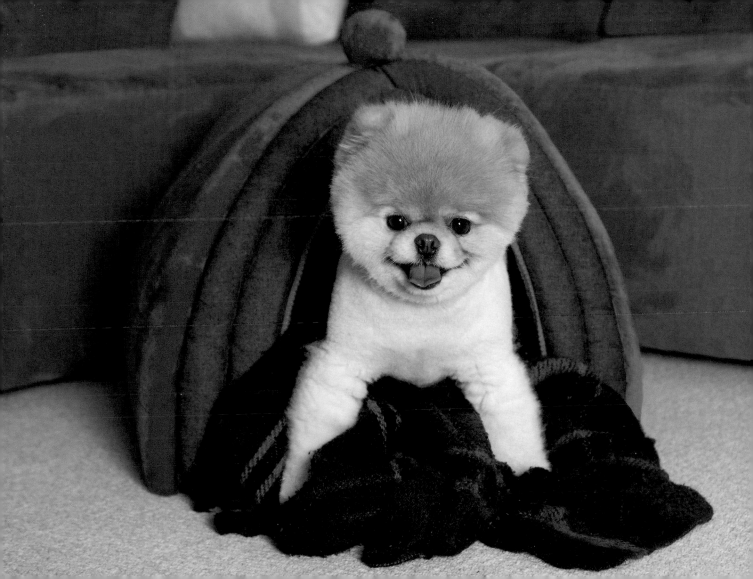

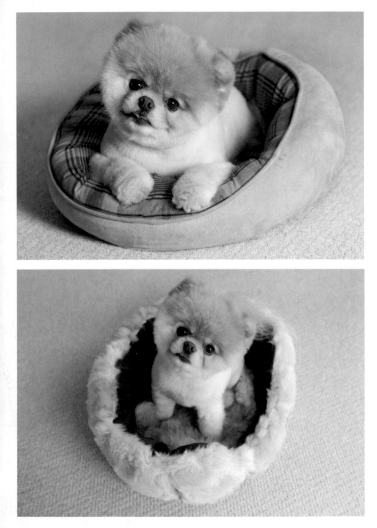

And this is where I nap.

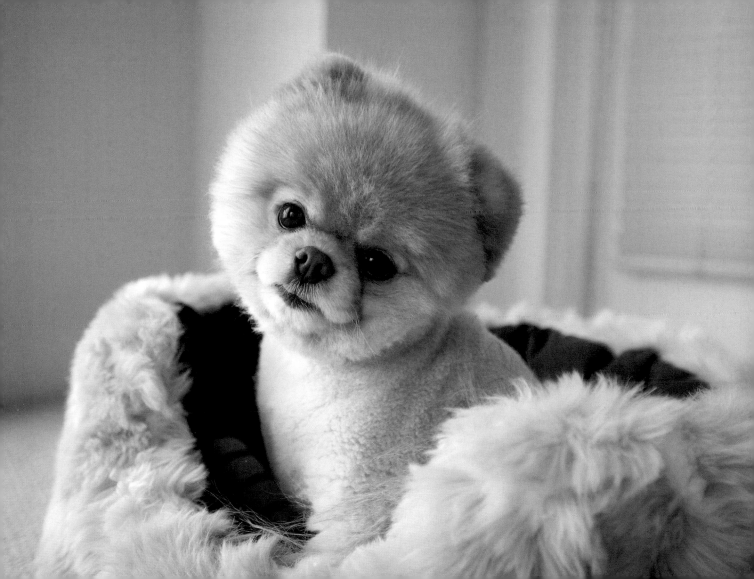

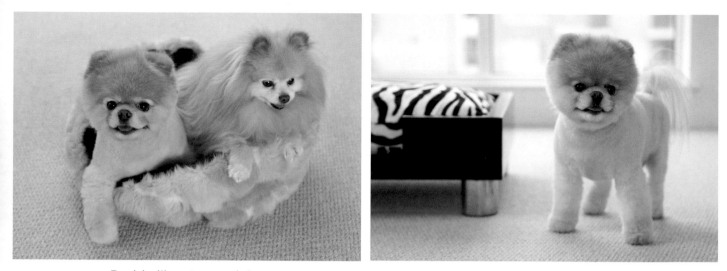

Buddy likes to sneak in.

Sometimes I nap in style.

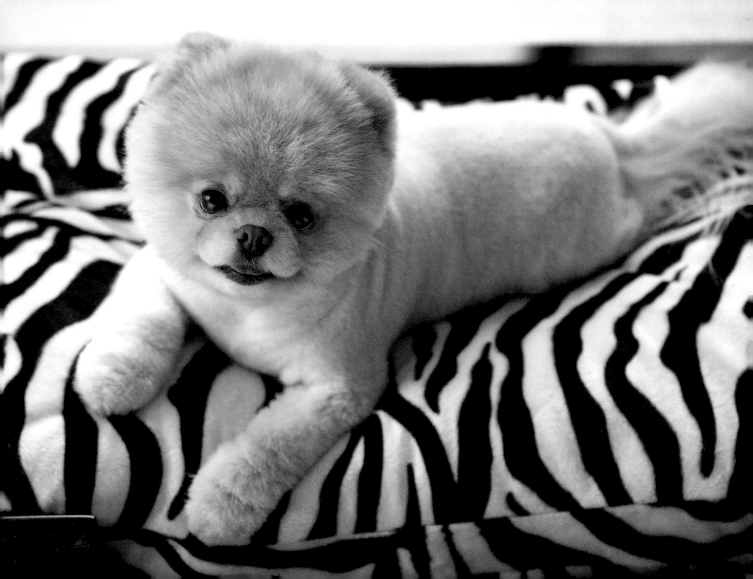

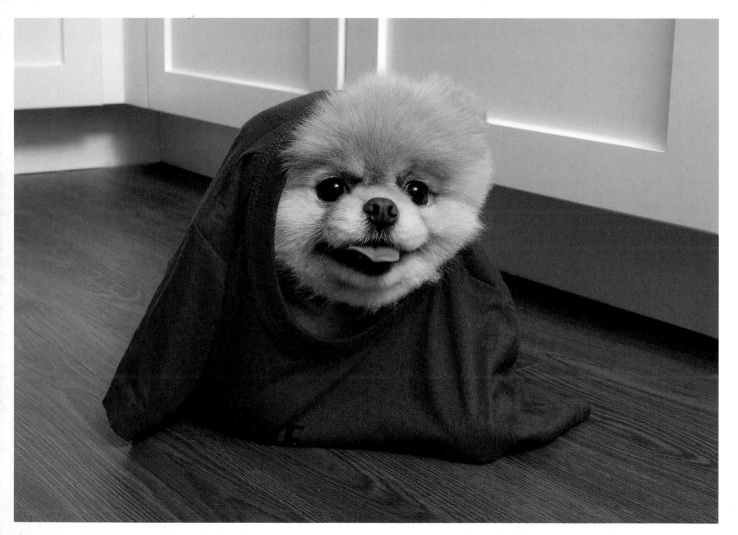

Fresh laundry makes a great nap-time blanket.

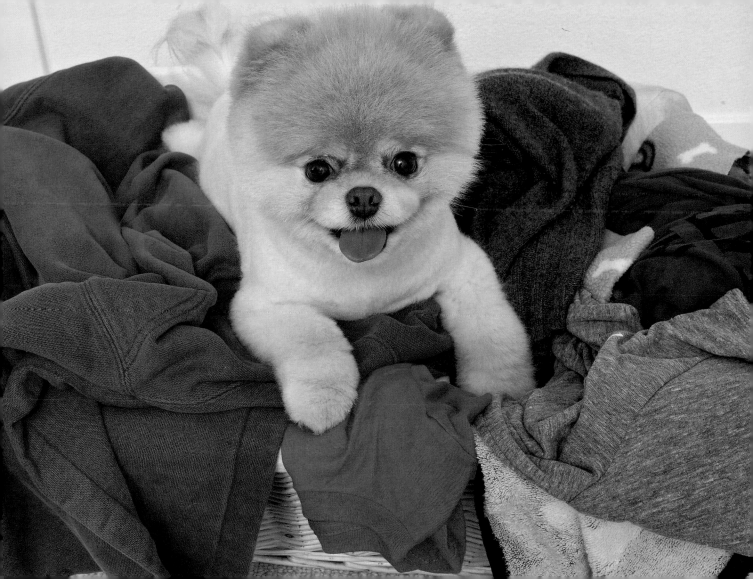

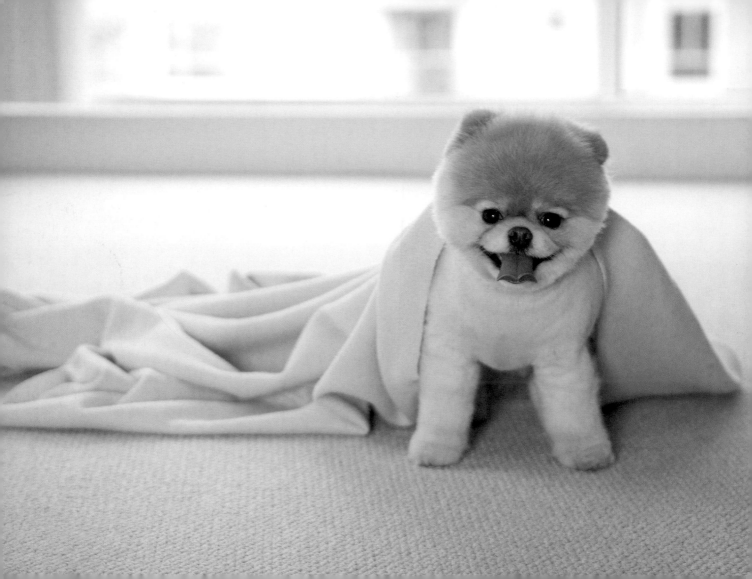

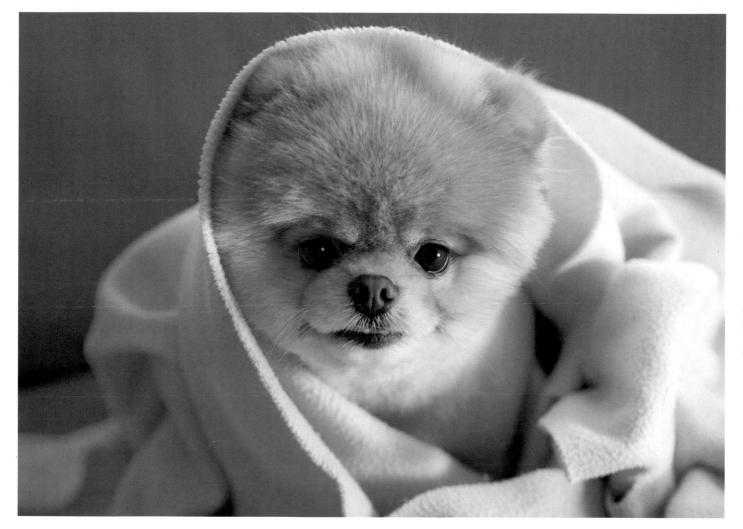

Blanket burritos are the best.

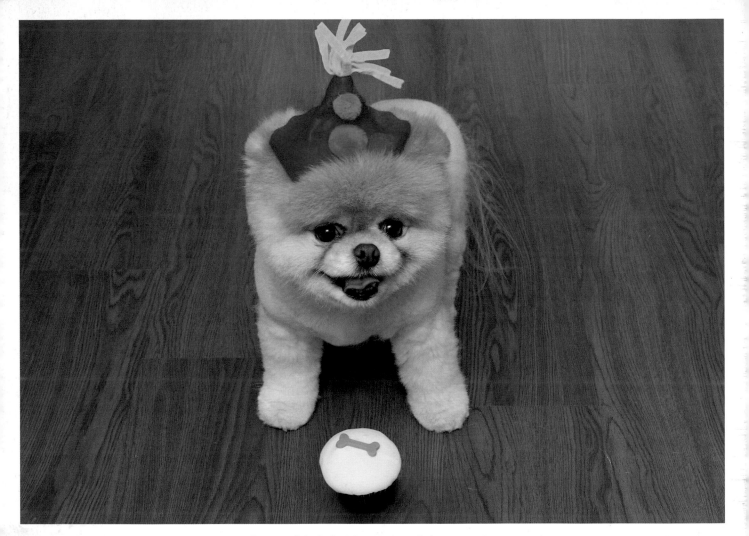

On my birthday I get special presents.

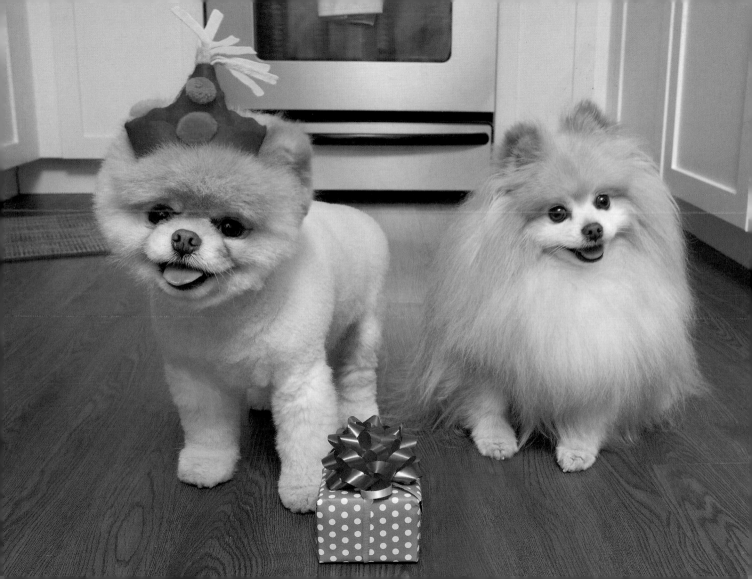

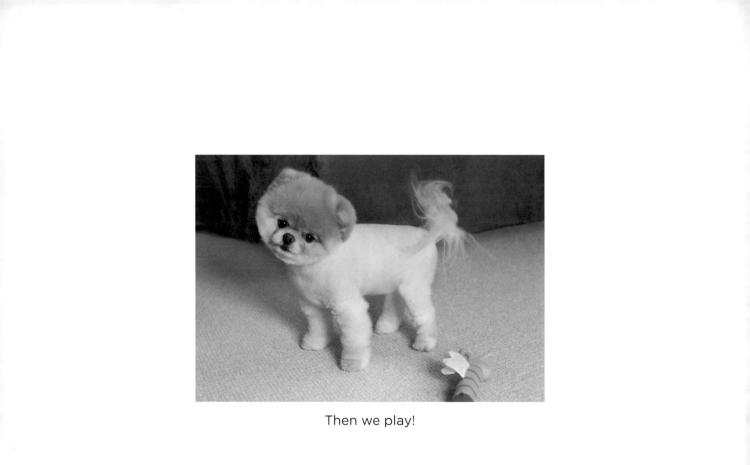

Then we play!

Cutie camouflage

Can you spot me?

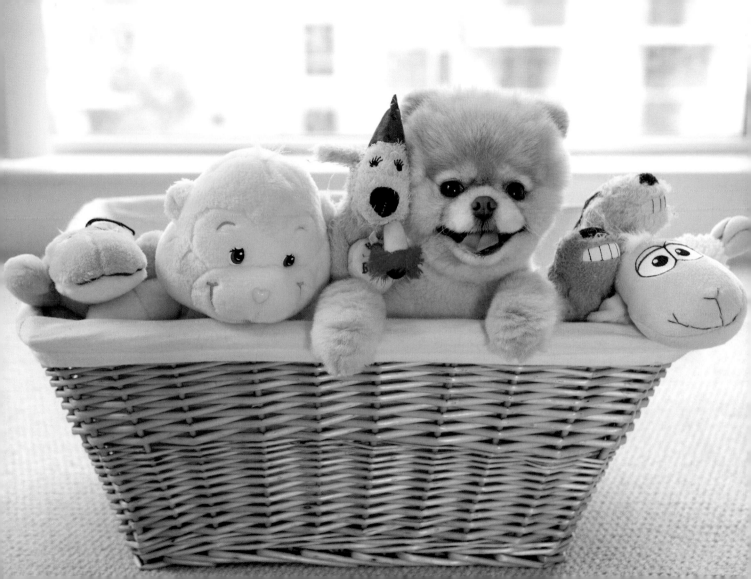

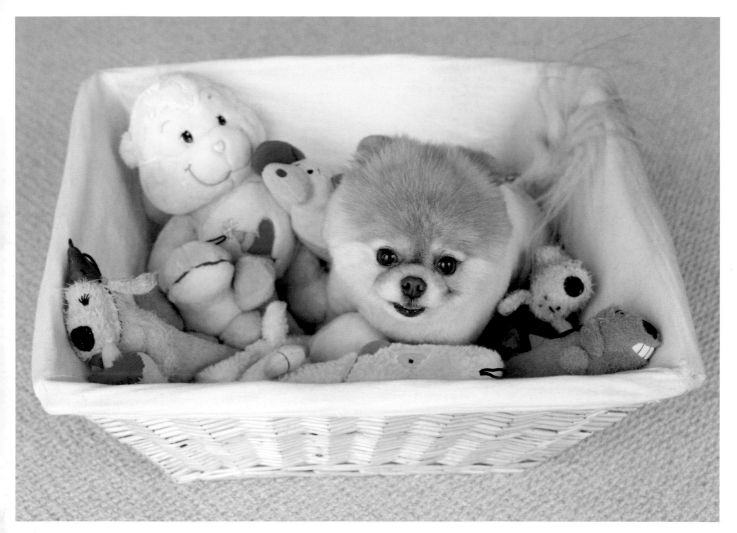

I would be the one with the giant head.

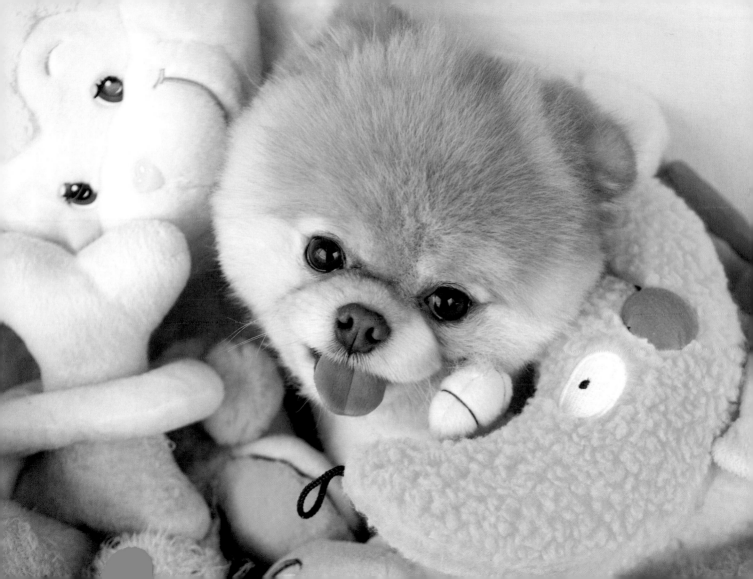

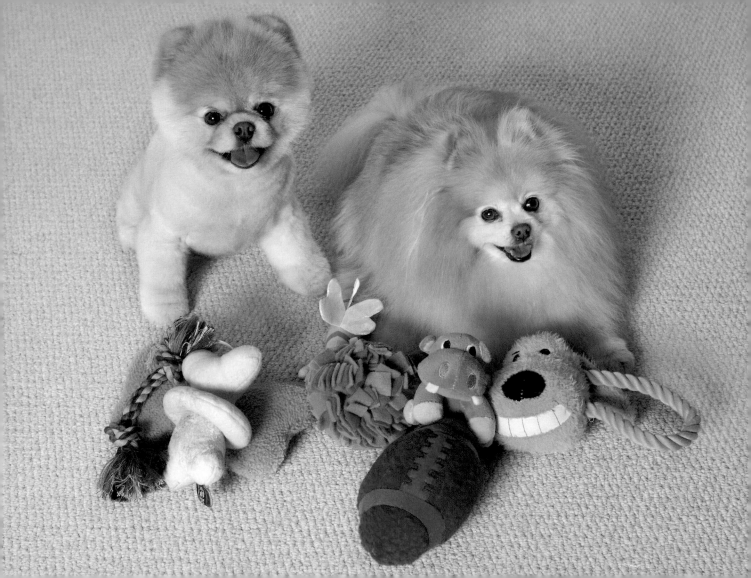

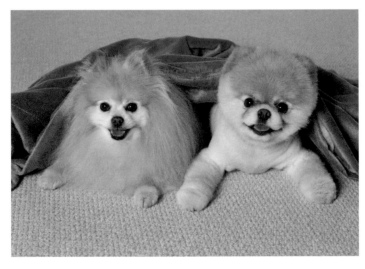

Then we do more of what we do best: nap!

Buddy and I play together.

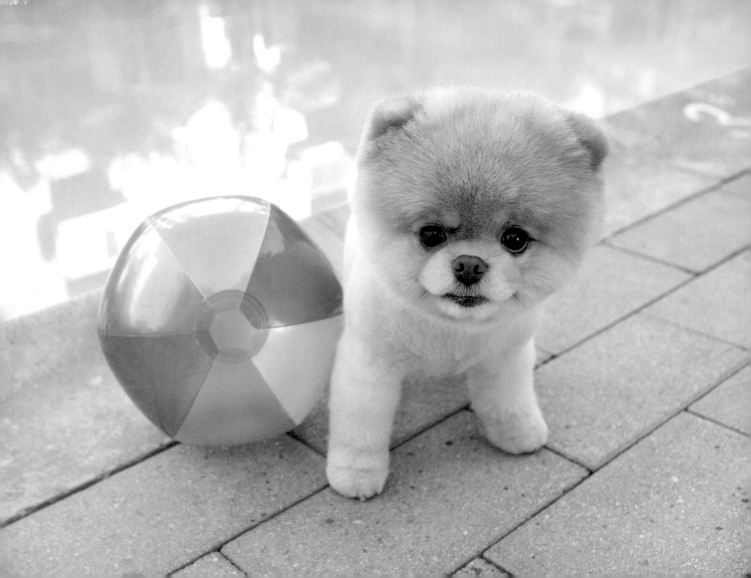

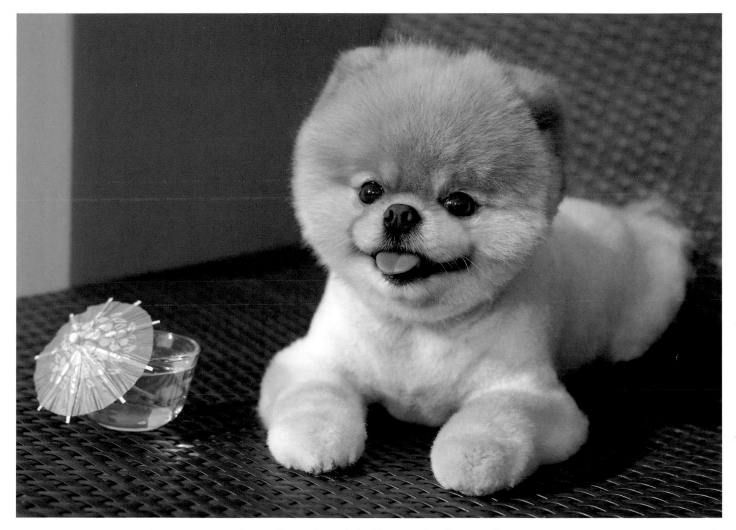

Sometimes I soak in the sun by the pool.

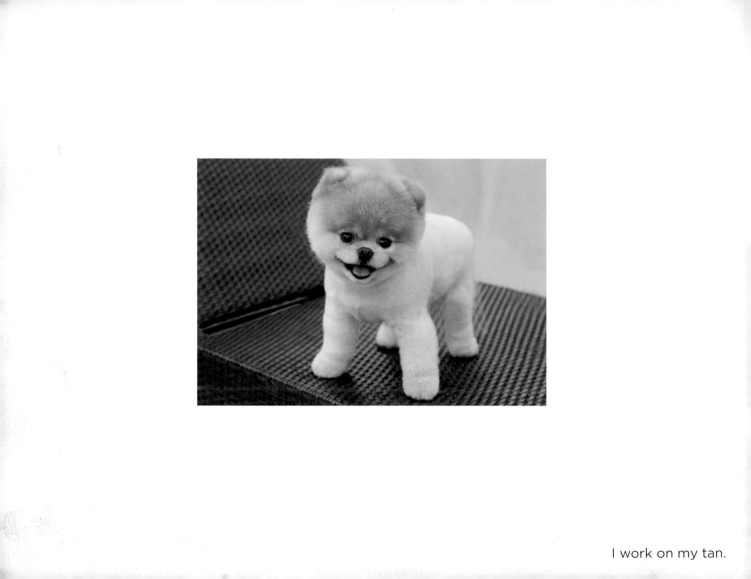

I work on my tan.

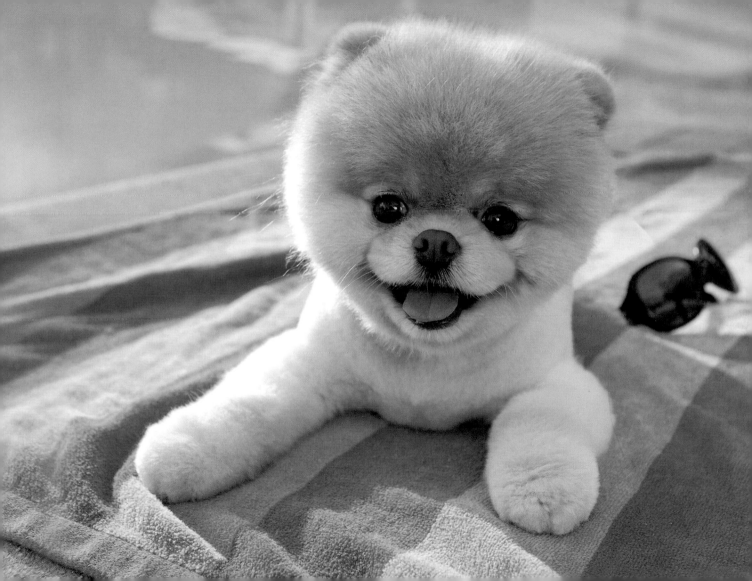

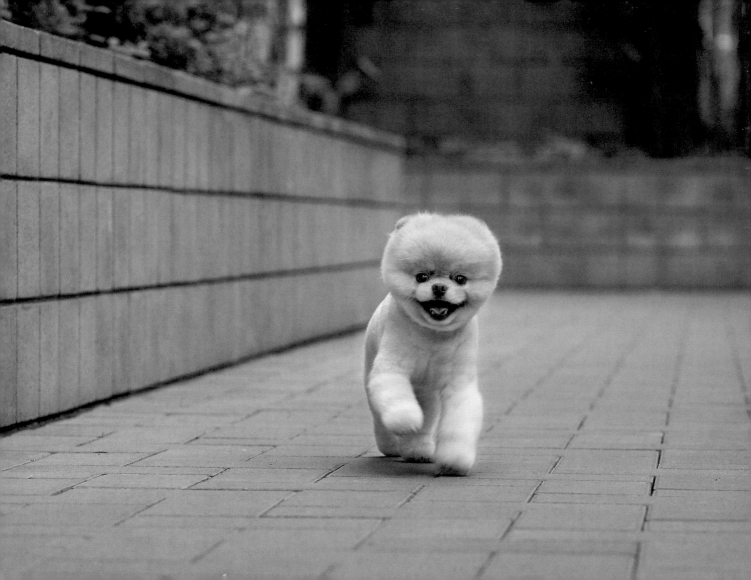

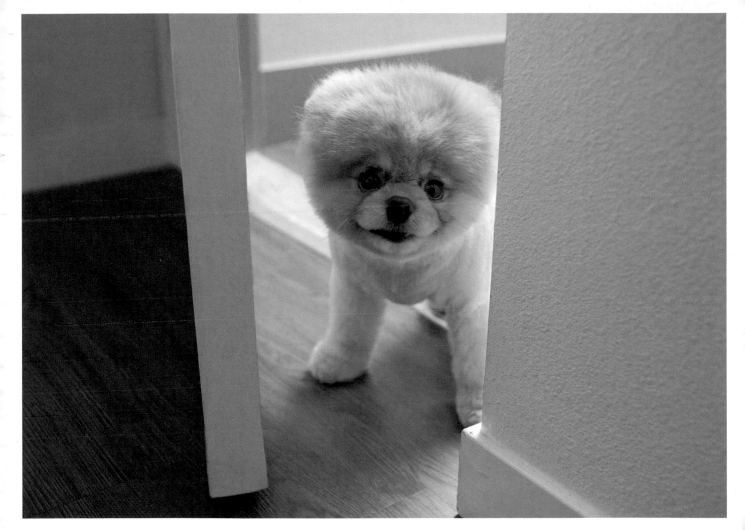

Time to head back home!

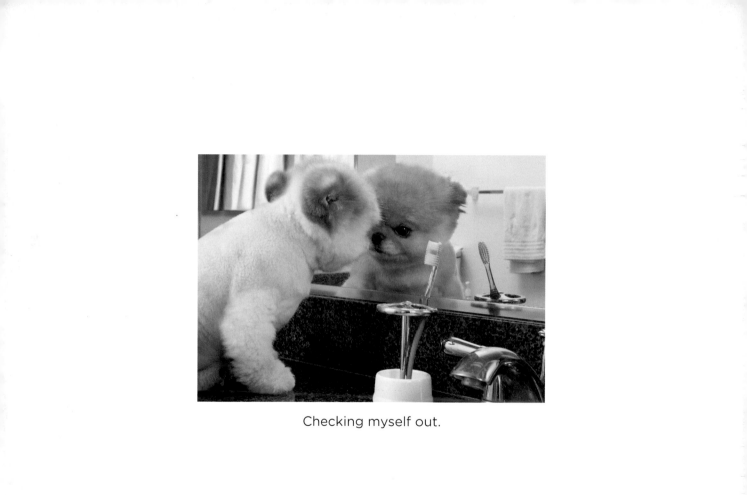

Checking myself out.

The sink is another nice snug spot.

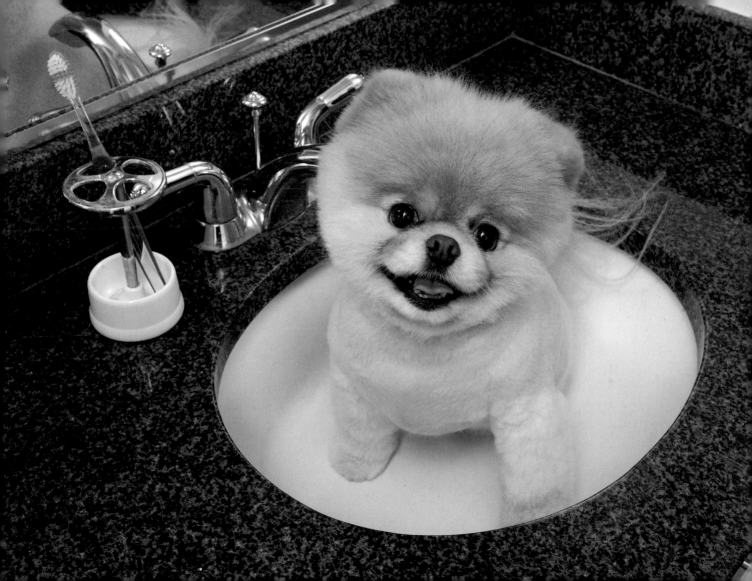

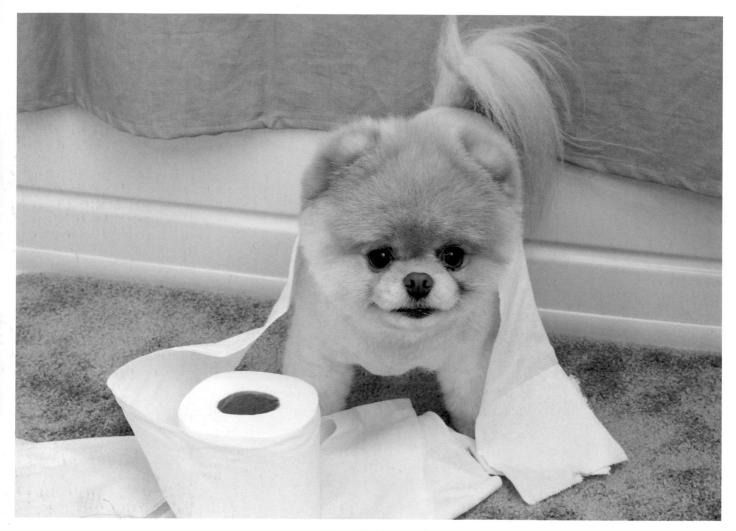

I can be a little naughty.

Bath time?

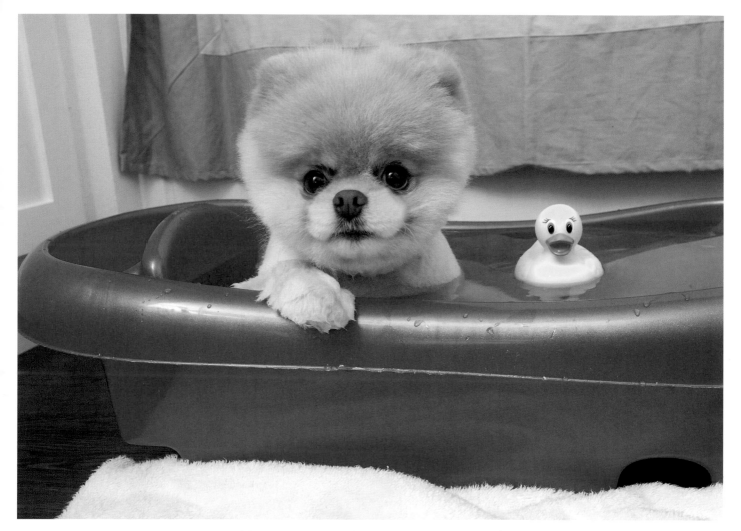

Bathing is not one of the highlights of my day.

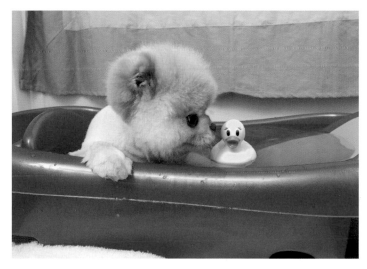

Duckie doesn't understand personal space.

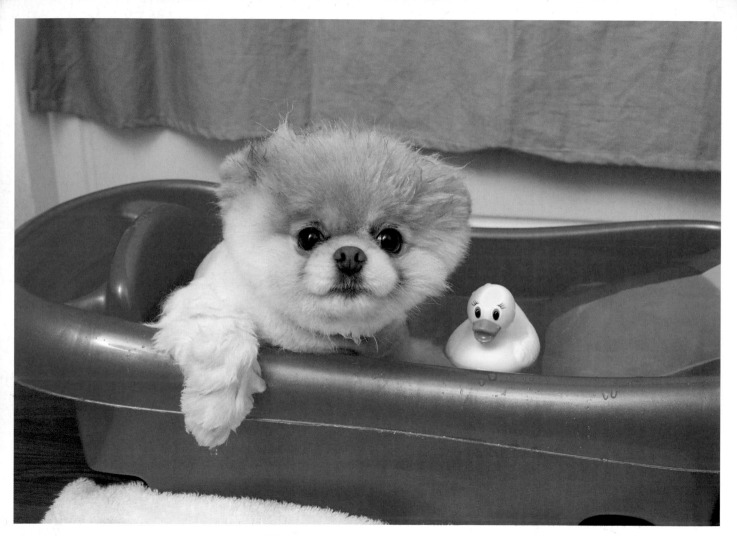

This is not a good look for me.

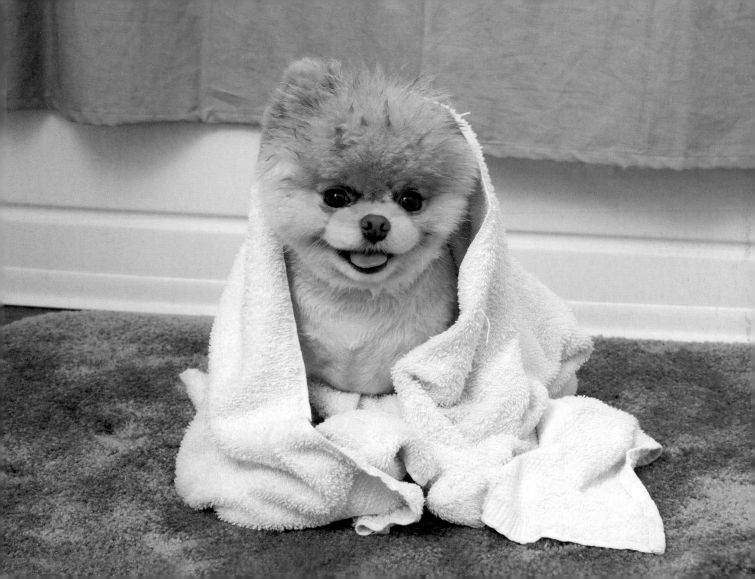

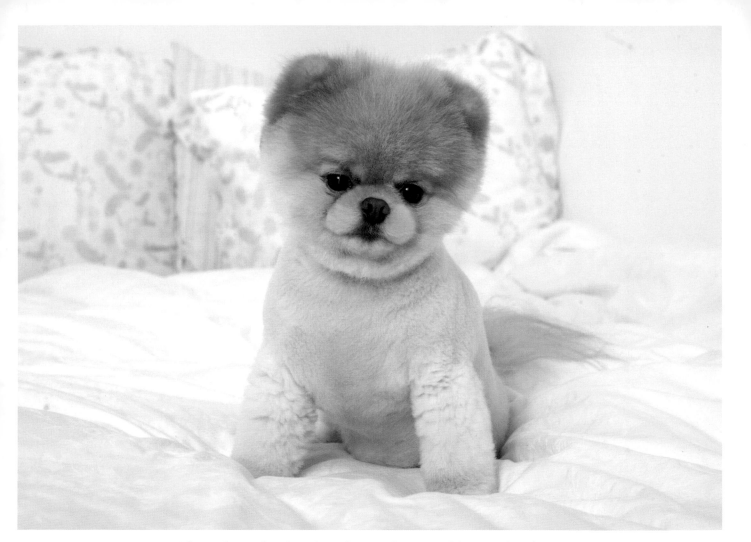

After a long day, it's time for my favorite thing again: sleep!

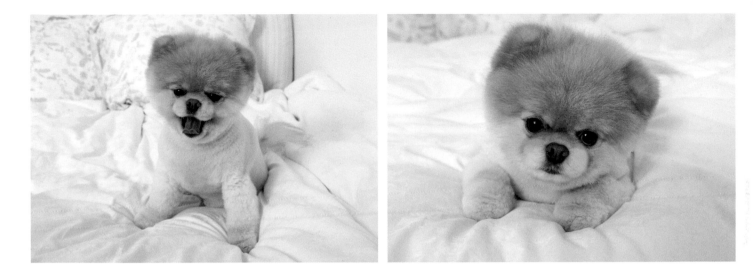

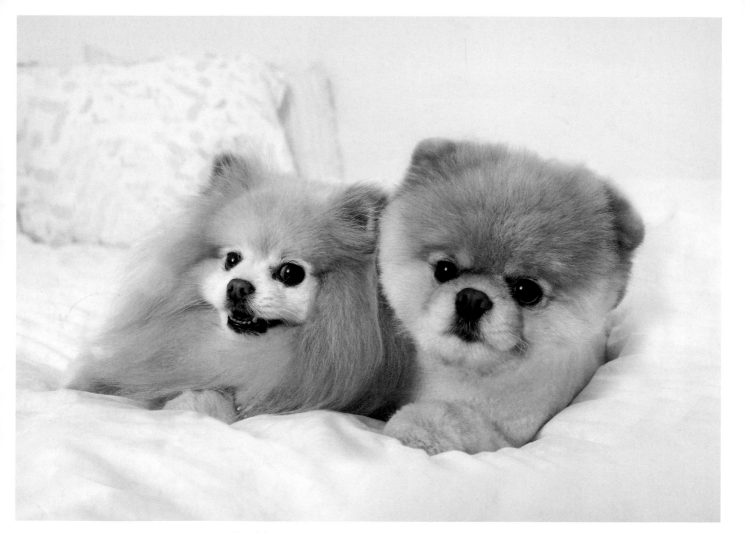

Buddy tries to get on my side of the bed.

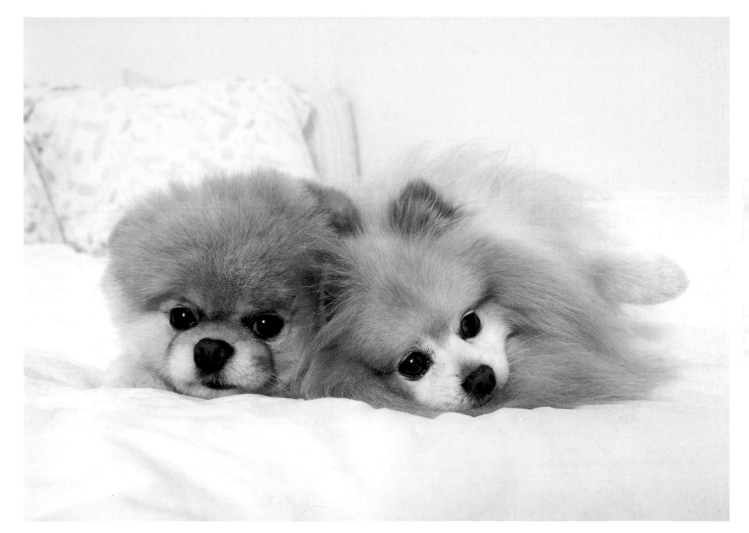

But we find that this way usually works best.

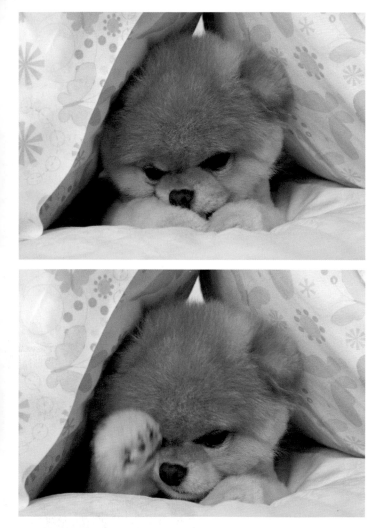

I get sleepy eyes and snuggle into the covers.

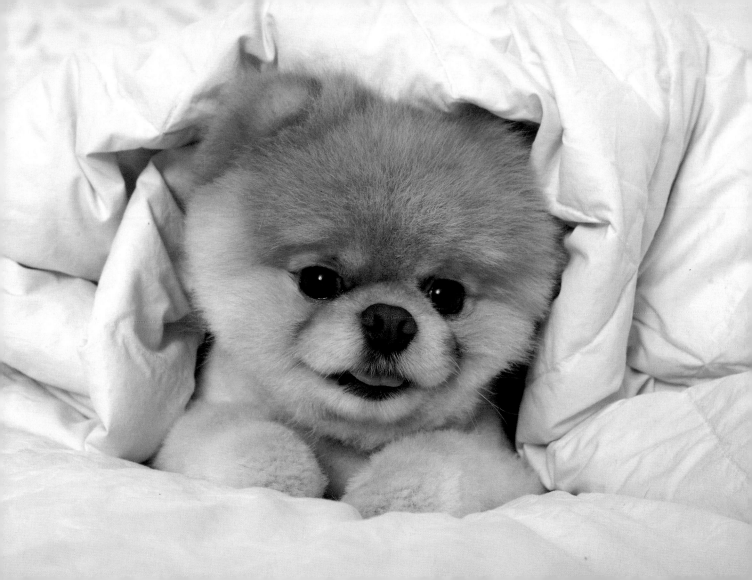

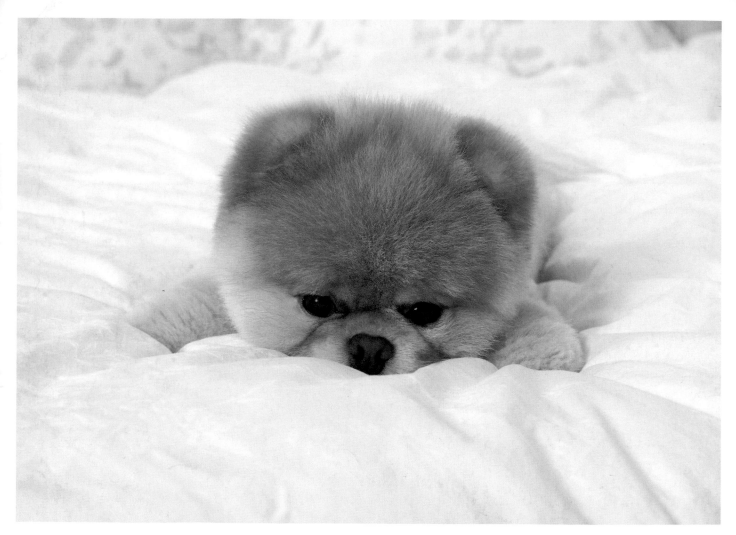

Good night!

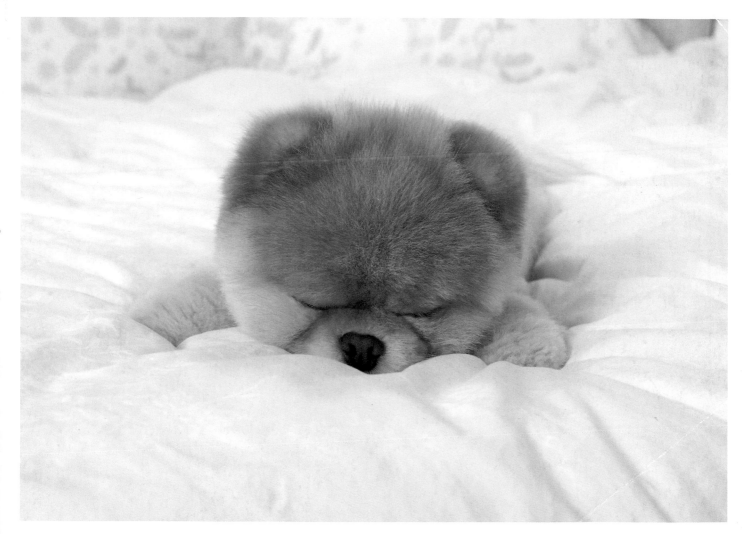

Sleep tight.

I dedicate this book to my best friend **Buddy**.
Thank you for always being by my side and
giving me a lead to follow.

I'd also like to thank my many **Facebook fans**
for loving a silly dog with a funny haircut.
I hope you enjoyed my story!